Also available by Michael Dumontier and Neil Farber

Constructive Abandonment
Animals with Sharpies

drawnandquarterly.com
personalmessageblog.blogspot.com

ISBN 978-1-77046-412-4
First edition: September 2021
Printed in China
10 9 8 7 6 5 4 3 2 1

Cataloguing data available from Library and Archives Canada

Published in the USA by Drawn & Quarterly, a client publisher of Farrar, Straus and Giroux. Published in Canada by Drawn & Quarterly, a client publisher of Raincoast Books. Published in the United Kingdom by Drawn & Quarterly, a client publisher of Publishers Group UK.

 Drawn & Quarterly acknowledges the support of the Government of Canada and the Canada Council for the Arts for our publishing program.

LIBRARY

Michael Dumontier and Neil Farber

Drawn & Quarterly

EXPLOSION OF LIFE

SET YOUR DOVE ALL THE WAY FREE

A BORING DAY OF MY LIFE IN FINE DETAIL

INTERVIEWS WITH INANIMATE OBJECTS

OH, MY ACHING BOOK

I WANTED TO TAKE YOU FOR A DRIVE SO I BUILT A ROAD AND INVENTED THE CAR.

TIDY SCRIBBLES

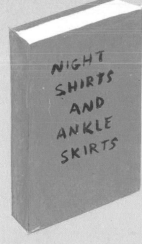

NIGHT SHIRTS AND ANKLE SKIRTS

YOU SHOULD CONSIDER YOUR WORDS, BECAUSE I WILL TAKE THEM SERIOUSLY.

A
BATHTUB
YOU CAN
SLEEP
IN
WITHOUT
DROWNING

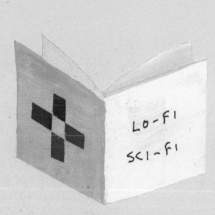

LO-FI
SCI-FI

WE HAVE
SOME PROBLEMS
IN HERE
(POINTS TO HEAD)

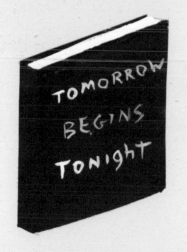

TOMORROW
BEGINS
TONIGHT

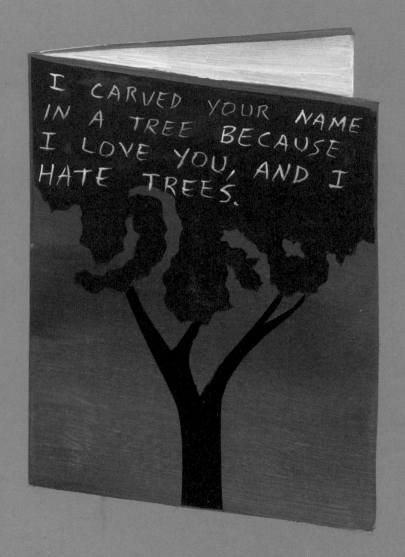

DON'T TALK TO ME FOR TOO LONG, YOU'll FALL IN LOVE.

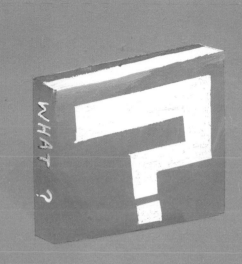

WHAT ?

DrINKING beer OUT OF a SOUP CAN AND VICE VersA

ONCE YOU'RE BULLETPROOF THEY'LL JUST MAKE A STRONGER BULLET

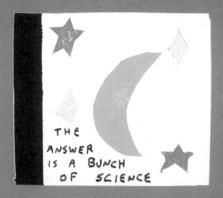

THE ANSWER IS A BUNCH OF SCIENCE

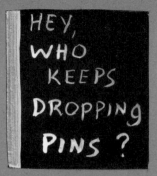

HEY, WHO KEEPS DROPPING PINS?

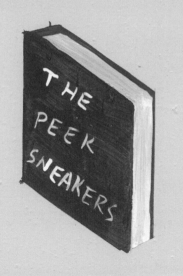

THE PEEK SNEAKERS

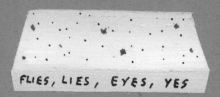

FLIES, LIES, EYES, YES

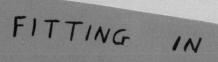

FITTING IN

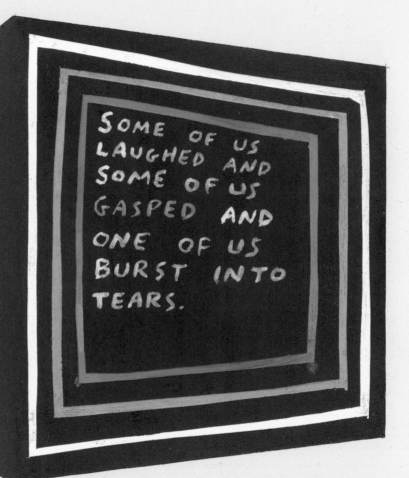

I DON'T HATE YOU, BUT I WON'T DATE YOU

WE HARVEST AND THEN WE BURN

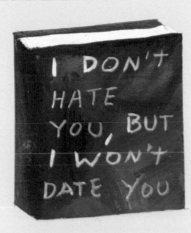

YOU CAN ONLY LEARN THE SAME THING FROM THE SAME MISTAKE SO MANY TIMES

BORN IN THE FETAL POSITION, DIE IN THE FATAL POSITION

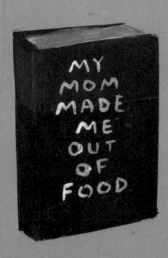

MY
MOM
MADE
ME
OUT
OF
FOOD

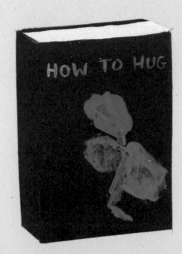

HOW TO HUG

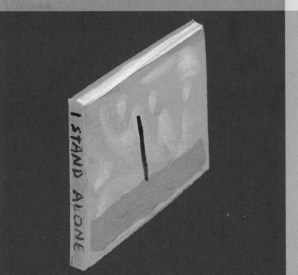

I STAND ALONE

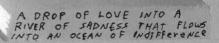

A DROP OF LOVE INTO A
RIVER OF SADNESS THAT FLOWS
INTO AN OCEAN OF INDIFFERENCE

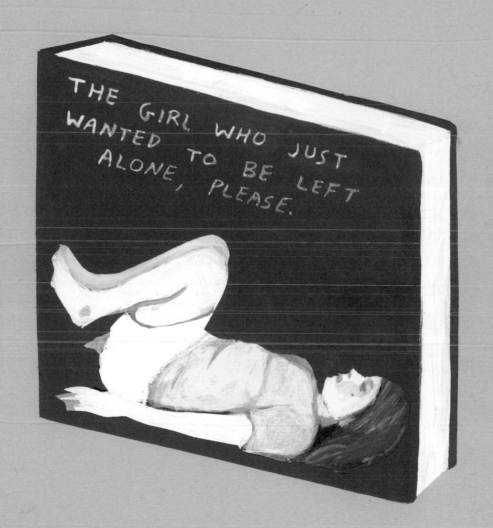

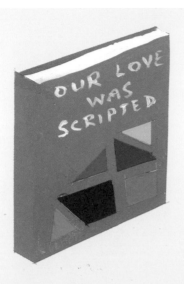

OUR LOVE WAS SCRIPTED

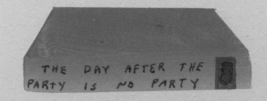

THE DAY AFTER THE PARTY IS NO PARTY

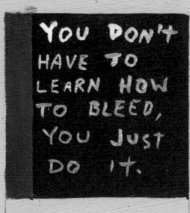

YOU DON'T HAVE TO LEARN HOW TO BLEED, YOU JUST DO IT.

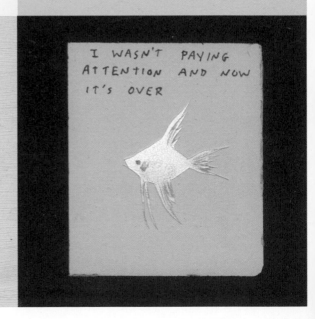

I WASN'T PAYING ATTENTION AND NOW IT'S OVER

WHETHER I
HELPED OR
NOT, AT
LEAST IT
WAS
APPARENT I
WAS
SMART.

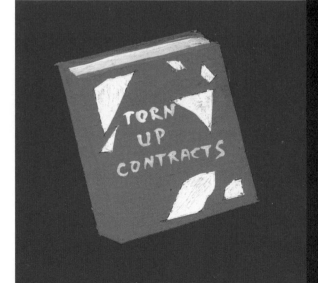

I TAKE
NO
SATISFACTION
AT
being
TERRIBLE
AT
EVERYthing

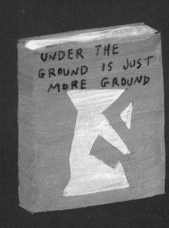

UNDER THE
GROUND IS JUST
MORE GROUND

TORN
UP
CONTRACTS

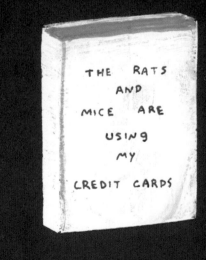

THE RATS
AND
MICE ARE
USING
MY
CREDIT CARDS

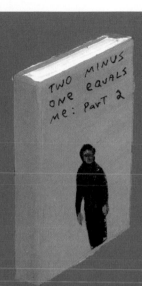

TWO MINUS ONE EQUALS ME: PART 2

MY TEETH
WILL NEVER
STOP
GROWING
MY HEART
WILL NEVER
STOP
LOVING

HER FACE WAS
MUSIC TO MY EAR

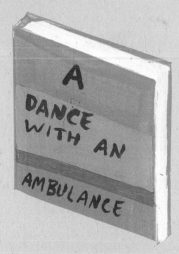

A
DANCE
WITH AN
AMBULANCE

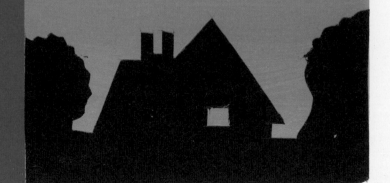

I TYPED THIS AS FAST AS I COULD

SHE Flourished IN The WILD

LOST VS FOUND

THE LIBRAKERY HAS BOOKS AND PIES

THE OUCH

600 WORD STORIES

MY LIFE FOR YOU TO READ

BENNY

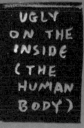

UGLY ON THE INSIDE (THE HUMAN BODY)

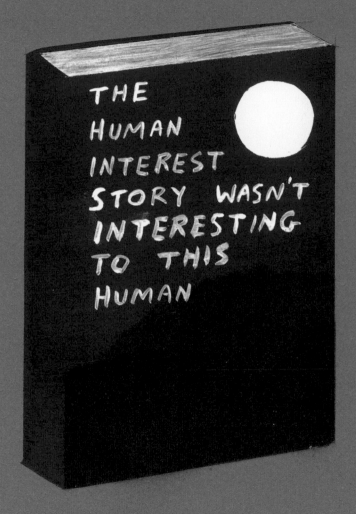

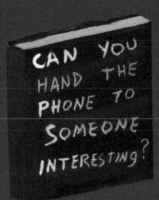

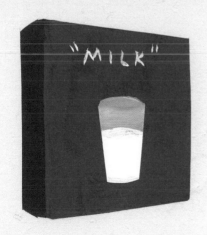

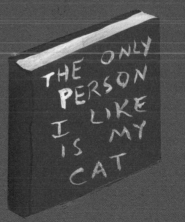

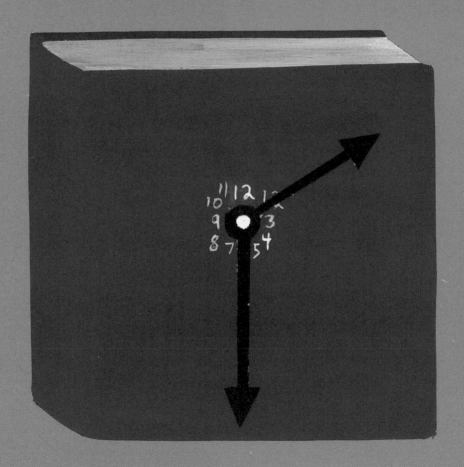

KILL ME ONCE,
SHAME ON YOU.

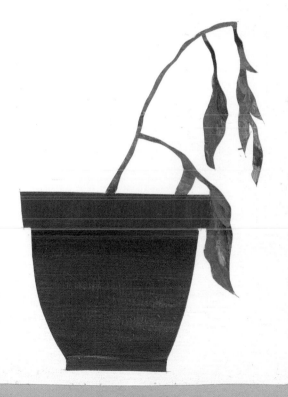

EVERY PERSON IN YOUR
FAMILY IS BASICALLY YOU

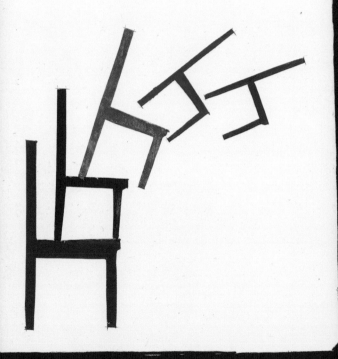

INSIDE OUT

INSIDE MY HOUSE,
OUT OF MY MIND.

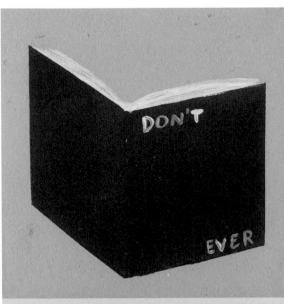

DON'T

EVER

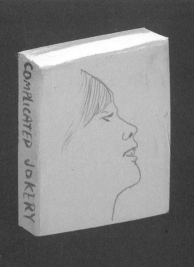

COMPLICATED JOKERY

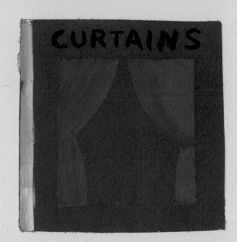

CURTAINS

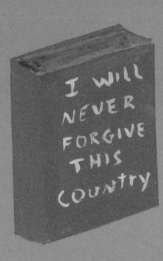

I WILL
NEVER
FORGIVE
THIS
COUNTRY

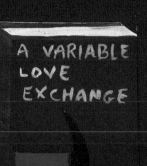

A VARIABLE LOVE EXCHANGE

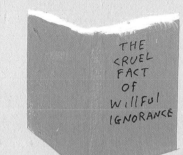

THE CRUEL FACT OF Willful IGNORANCE

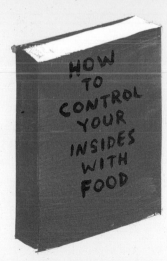

HOW TO CONTROL YOUR INSIDES WITH FOOD

IF ANYBODY HAS ANY MONEY, IT TURNS OUT YOU OWE ME SOME MONEY.

I WAS
Just
Kidding
When I
said I do

DIG
HIM UP,
LET'S
KILL HIM
AGAIN

MY
WAY
IS
THE
HIGHWAY

THE WIGGLE ROOM

YOU CAN
BURN THE
BRIDGE, BUT
I'LL JUST
SWIM

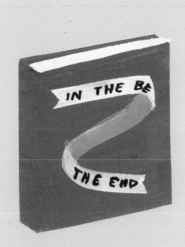

IN THE BE

THE END

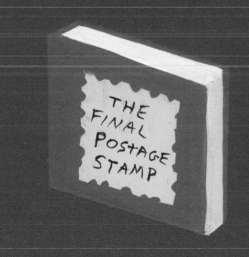

THE
FINAL
POSTAGE
STAMP

I
STOPPED
THINKING
NEW
THOUGHTS
A LONG
TIME AGO

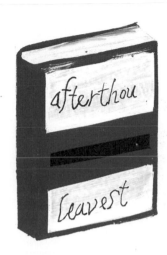

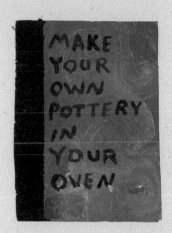

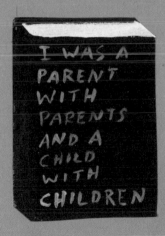

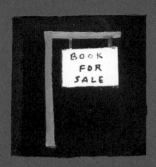

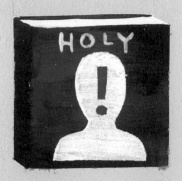

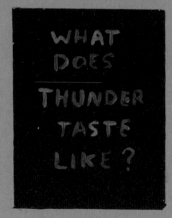

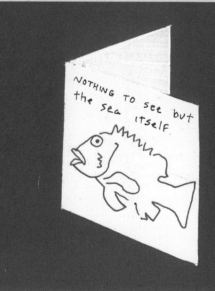

You defuse the bomb, and the clock starts over, time and time again, until *you* make a mistake, or walk away.

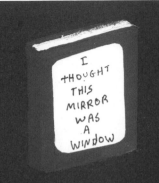

I THOUGHT THIS MIRROR WAS A WINDOW

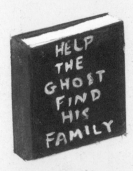

HELP THE GHOST FIND HIS FAMILY

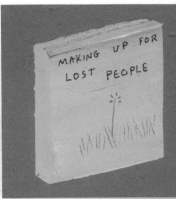

MAKING UP FOR LOST PEOPLE

I said The wrong words, but I Pronounced Them correctly

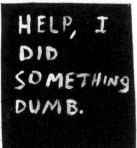

HELP, I DID SOMETHING DUMB.

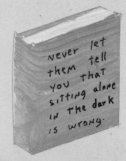

Never let them tell you That sitting alone In The dark is wrong.

EVERY Word STANDS ALONE

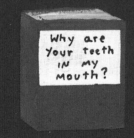

Why are your teeth IN my mouth?

THE BAND WHO WHEN THEY PLAYED SOUNDED LIKE DEATH

HEY
THAT'S
THE SAME
SADNESS
I HAVE

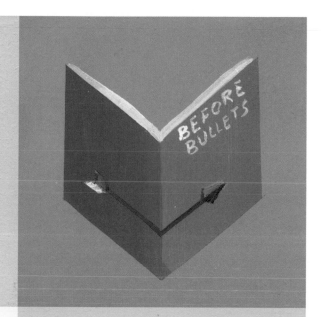

BEFORE
BULLETS

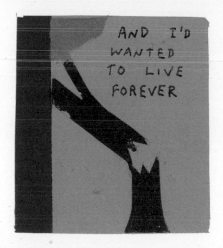

AND I'D
WANTED
TO LIVE
FOREVER

QUESTIONS
WHERE THE
ASKER
DOESN'T
CARE
ABOUT
THE
ANSWER

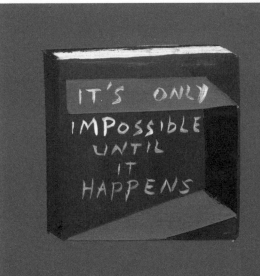

IT'S ONLY IMPOSSIBLE UNTIL IT HAPPENS

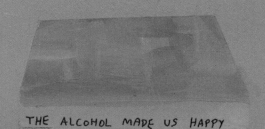

THE ALCOHOL MADE US HAPPY

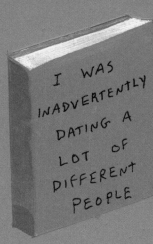

I WAS INADVERTENTLY DATING A LOT OF DIFFERENT PEOPLE

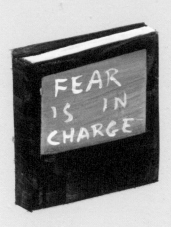

FEAR IS IN CHARGE

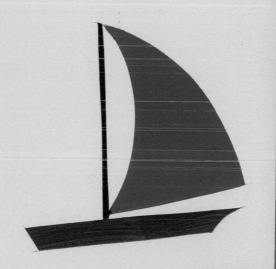

YOU WON'T END UP WHERE YOU PLAN, BUT YOU STILL NEED THE PLAN.

I DIDN'T
REPLACE YOU,
THE TIME WE
WOULD'VE SPENT

TOGETHER,

I NOW
SPEND
ALONE.

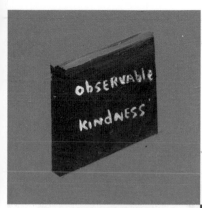

observable kindness

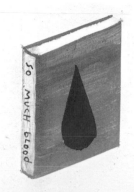

SO MUCH BLOOD

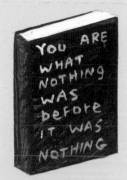

YOU ARE WHAT NOTHING WAS before IT WAS NOTHING

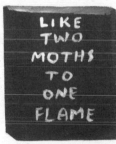

LIKE TWO MOTHS TO ONE FLAME

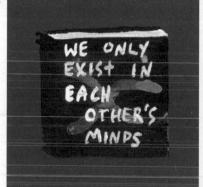

WE ONLY EXIST IN EACH OTHER'S MINDS

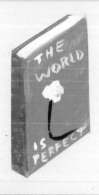

THE WORLD IS PERFECT

DON'T Let go of my hand, it's the ONLY WAY I KNOW I'M still ALIVE

THE BLAME

THE cookies ARE ALREADY IN MILK WHEN YOU BUY THEM

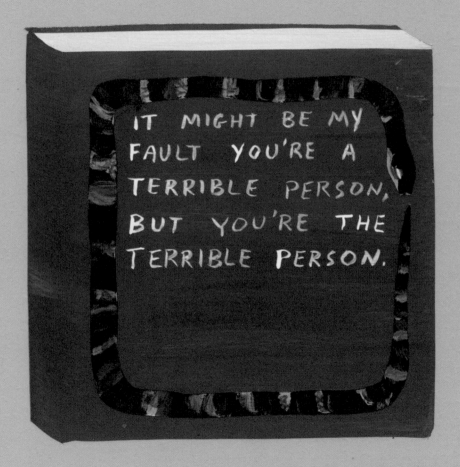

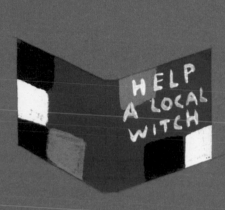

HELP
A LOCAL
WITCH

FEELING
AROUND
IN THE
DARK
FOR MY
DARK
FEELINGS

I HATED IT
EVERY TIME,
BUT I DID
It EVERY
TIME

IF YOUR
PICKLE
BECOMES
A CUCUMBER
YOU MUST
REPICKLE
IT

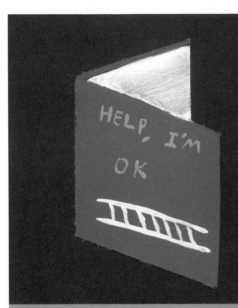

HELP, I'M OK

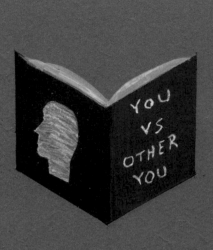

YOU VS OTHER YOU

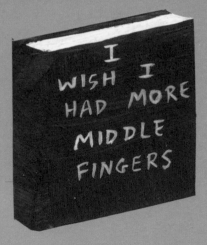

I WISH I HAD MORE MIDDLE FINGERS

EVERY opportunity taken is A million OPPORTUNITIES LOST

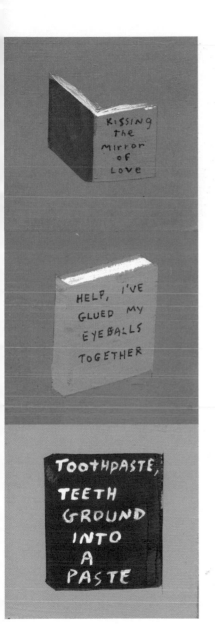

KISSING
THE
MIRROR
OF
LOVE

HELP, I'VE
GLUED MY
EYEBALLS
TOGETHER

TOOTHPASTE,
TEETH
GROUND
INTO
A
PASTE

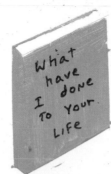

What
have
I done
To Your
Life

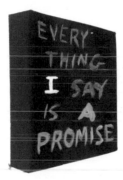

EVERY
THING
I SAY
IS A
PROMISE

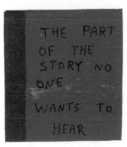

THE PART
OF THE
STORY NO
ONE
WANTS TO
HEAR

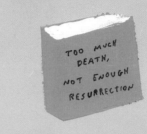

TOO MUCH
DEATH,
NOT ENOUGH
RESURRECTION

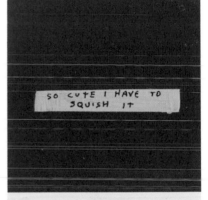

SO CUTE I HAVE TO
SQUISH IT

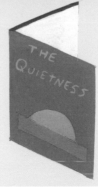

THE
QUIETNESS

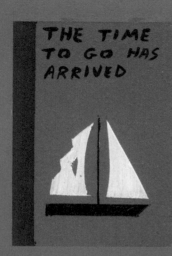

THE TIME TO GO HAS ARRIVED

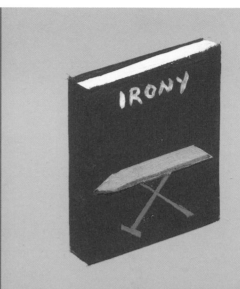

IRONY

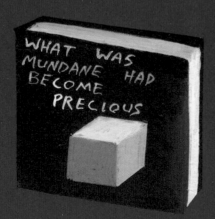

WHAT WAS MUNDANE HAD BECOME PRECIOUS

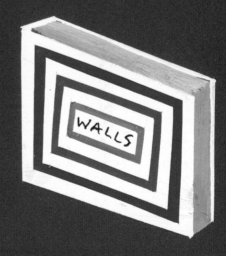

WALLS

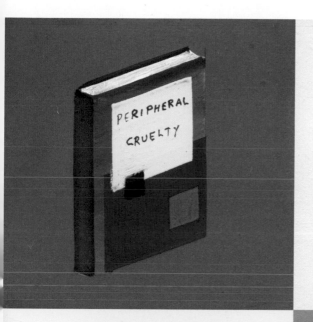

PERIPHERAL CRUELTY

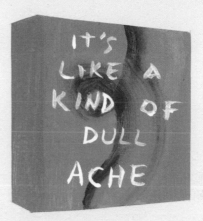

IT'S LIKE A KIND OF DULL ACHE

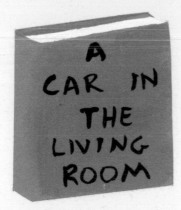

A CAR IN THE LIVING ROOM

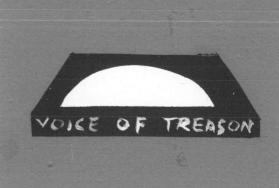

VOICE OF TREASON

BETTER STAY
UP ALL
NIGHT
BEFORE
STARTING
THAT
NEW
JOB.

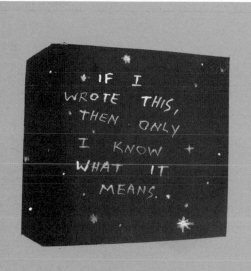

IF I WROTE THIS, THEN ONLY I KNOW WHAT IT MEANS.

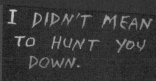

I DIDN'T MEAN TO HUNT YOU DOWN.

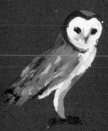

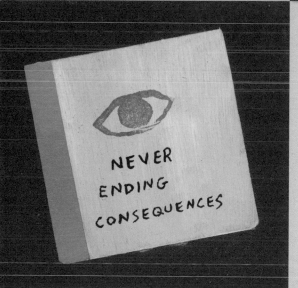

NEVER ENDING CONSEQUENCES

SHOW ME WHERE YOU WOULD LIKE IT TO HURT

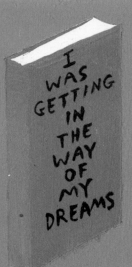

NOSE

MOUTH

THANKS
HALF
A
MILLION

ESOTERIC
EROTICA

TODAY IS
THE DAY
I WILL
MEASURE
ALL OTHER
DAYS
AGAINST

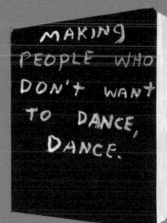

MAKING
PEOPLE WHO
DON'T WANT
TO DANCE,
DANCE.

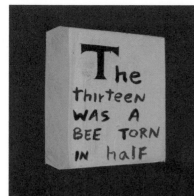

The thirteen WAS A BEE TORN IN half

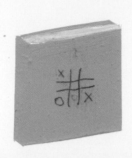

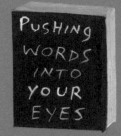

PUSHING WORDS INTO YOUR EYES

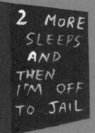

2 MORE SLEEPS AND THEN I'M OFF TO JAIL

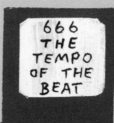

666 THE TEMPO OF THE BEAT

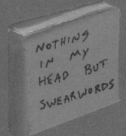

NOTHING IN MY HEAD BUT SWEARWORDS

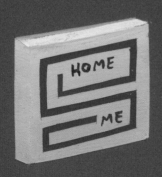

HOME ME

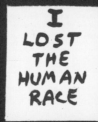

I LOST THE HUMAN RACE

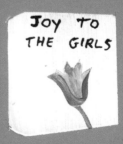

Joy TO THE GIRLS

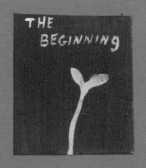

THE BEGINNING

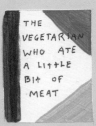

THE VEGETARIAN WHO ATE A LITTLE BIT OF MEAT

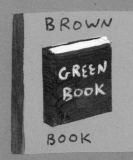

BROWN

GREEN BOOK

BOOK

THAT'S pretty close, HERE'S A CIGAR

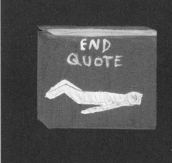

END QUOTE

I GOT A HANDSHAKE FOR MY BIRTHDAY

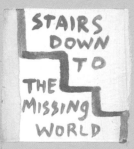

STAIRS DOWN TO THE MISSING WORLD

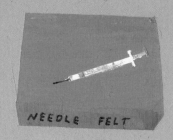

NEEDLE FELT

I'M AT A LOSS FOR WORDS STORIES

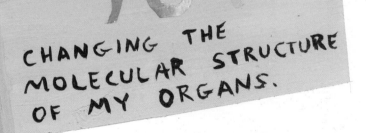

HE WAS GIVING OFF
ELECTROMAGNETIC
PULSES THAT WERE

CHANGING THE
MOLECULAR STRUCTURE
OF MY ORGANS.

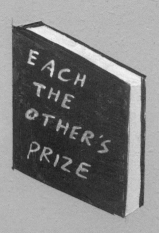

EACH THE OTHER'S PRIZE

WHAT THE EARTH REALLY THINKS OF THE MOON

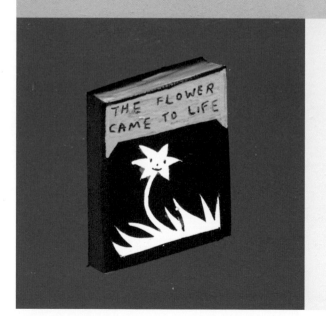

THE FLOWER CAME TO LIFE

THIS RIVER FLOWS BOTH WAYS

MAGIC SQUIRREL.

NOT ONLY ARE YOU THE ONLY YOU. YOU ARE ALSO NOT ONLY YOU.

I LIKED ME, BUT THEN I DID WHAT I DID.

ABSOLUTE NUDITY

YOU CAN talk all you like, my ears are ON strike.

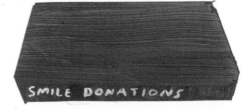

SMILE DONATIONS

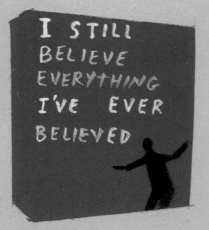

I STILL BELIEVE EVERYTHING I'VE EVER BELIEVED

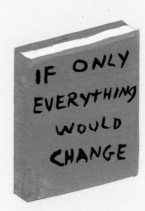

IF ONLY EVERYTHING WOULD CHANGE

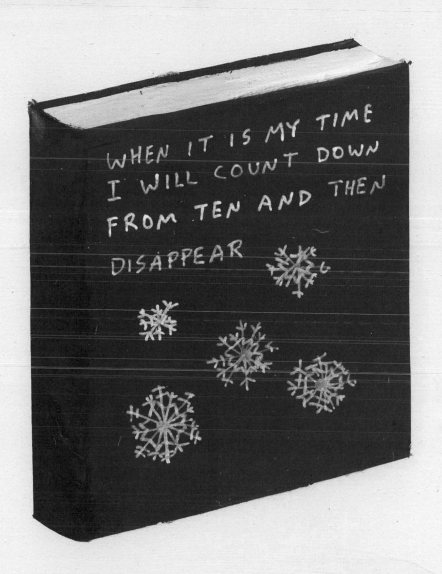

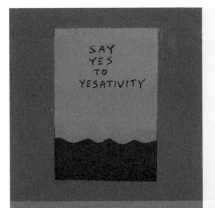

SAY YES TO YESATIVITY

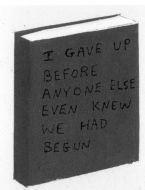

I GAVE UP BEFORE ANYONE ELSE EVEN KNEW WE HAD BEGUN

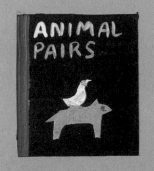

ANIMAL PAIRS

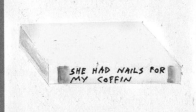

MY LIFE WAS OVER AND I WANTED TO GO AGAIN

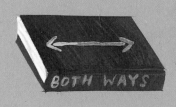

SHE HAD NAILS FOR MY COFFIN

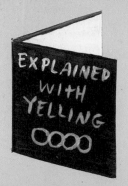

EXPLAINED WITH YELLING

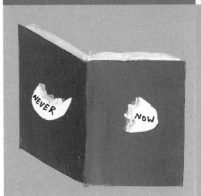

NEVER NOW

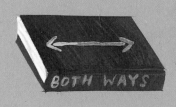

BOTH WAYS

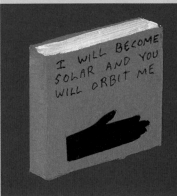

I WILL BECOME SOLAR AND YOU WILL ORBIT ME

ONE MINUTE
YOU HAVE ONE
MINUTE TO
LIVE, THE
NEXT YOU
DON'T.

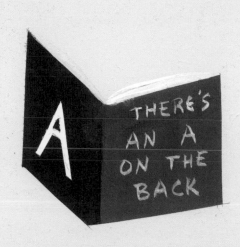

A THERE'S
 AN A
 ON THE
 BACK

I JUST NOTICED
THAT THE TREES
ARE MADE
OF BONES AND
THE RIVERS
ARE FILLED
WITH BLOOD

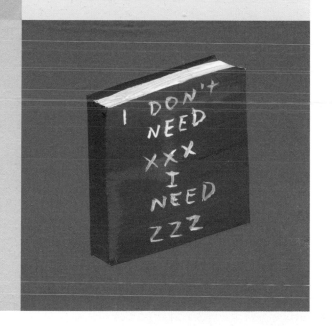

I DON'T
NEED
XXX
I
NEED
ZZZ

MY SING
ALONGS
WERE NOW
SING
ALONES

I+ WILL TAKE
YOU lONGER TO
READ THAN IT
TOOK ME TO WRITE

BROKEN LAWS AND
MISPLACED BRAS

EVERYONE
CRIES IF
YOU POKE
THEM IN
THE EYES

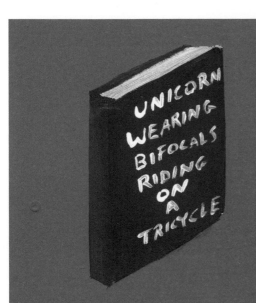

UNICORN
WEARING
BIFOCALS
RIDING
ON
A
TRICYCLE

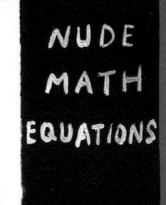

THE PILOT BORROWED A CUP OF SUGAR FROM THE CO-PILOT

I married someone less than one second older than me

NUDE
MATH
EQUATIONS

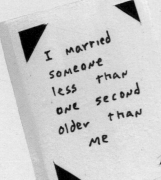

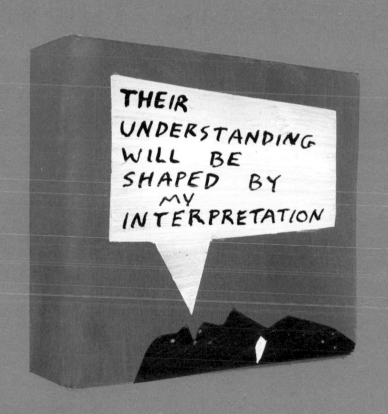

MY
LAST
MEAL
WAS
COLD

A LITTLE
DIRT TOWN
FOR ANTS

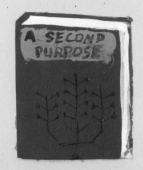

A SECOND
PURPOSE

THESE
THINGS

NOTHING IS
endless, and
the end of
everything
is
nothingness.

RECORD
YOUR
LOVE

A
NEW
CHARACTER
ON
EVERY
PAGE

blurry pictures

MY LOST
CONTACT
LENS
BURNED
DOWN
THE
NATIONAL
FOREST

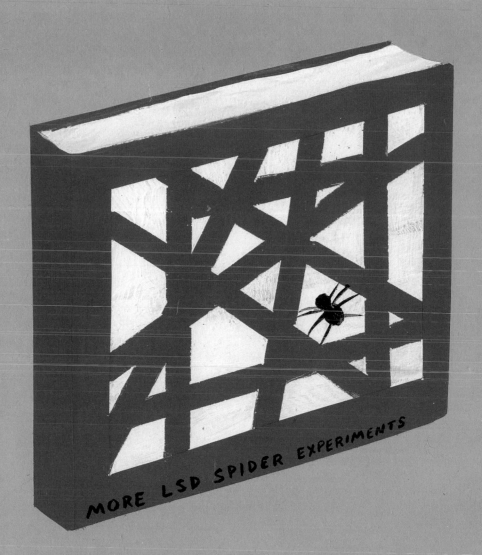

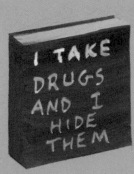

I TAKE DRUGS AND I HIDE THEM

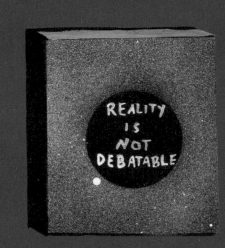

REALITY IS NOT DEBATABLE

LISTENING TO SAD MUSIC, WATCHING CHILDREN PLAY

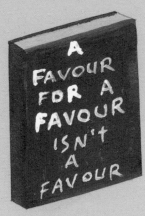

A FAVOUR FOR A FAVOUR ISN'T A FAVOUR

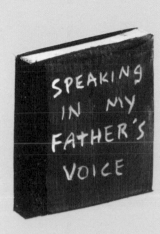

SPEAKING IN MY FATHER'S VOICE

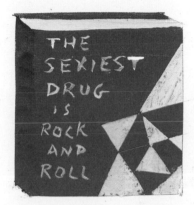

THE SEXIEST DRUG IS ROCK AND ROLL

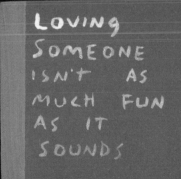

LOVING SOMEONE ISN'T AS MUCH FUN AS IT SOUNDS

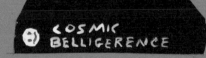

COSMIC BELLIGERENCE

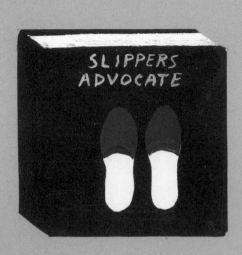

SLIPPERS ADVOCATE

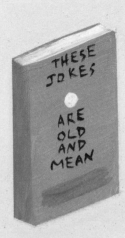

THESE JOKES ARE OLD AND MEAN

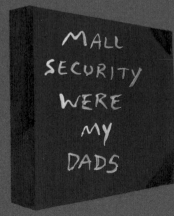

MALL SECURITY WERE MY DADS

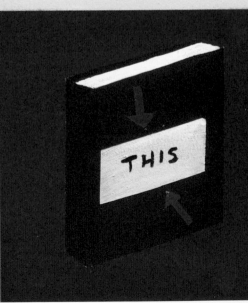

THIS

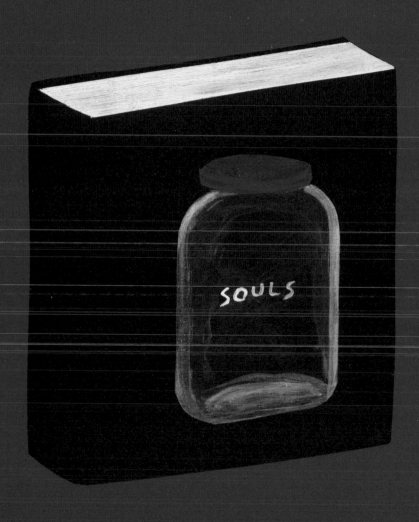

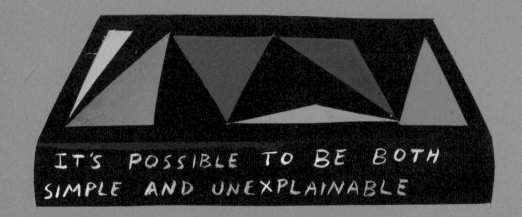

A ROOM
WITH A
VIEW,
BUT NO
WINDOW

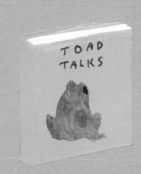

TOAD
TALKS

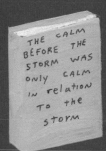

THE CALM
BEFORE THE
STORM WAS
ONLY CALM
IN relation
TO the
STORM

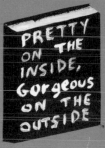

PRETTY
ON THE
INSIDE,
Gorgeous
ON THE
OUTSIDE

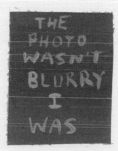

THE
PHOTO
WASN'T
BLURRY
I
WAS

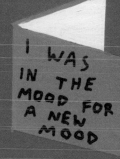

I WAS
IN THE
MOOD FOR
A NEW
MOOD

How can
We talk
When I
have No
voice and
You have
NO EARS?

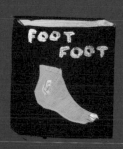

FOOT
FOOT

PUBLIC
NUDITY
IS NOT
A
PROFESSION

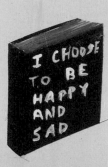

I CHOOSE TO BE HAPPY AND SAD

JuNe, July, August, Remember, october

NOCTURNAL MISSIONS

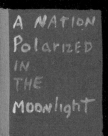

A NATION Polarized IN THE Moonlight

NOTHING TO SAY AND NO ONE TO SAY IT TO

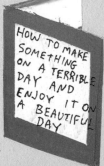

HOW TO MAKE SOMETHING ON A TERRIBLE DAY AND ENJOY IT ON A BEAUTIFUL DAY

SHE RAN AND RAN AND RAN AND RAN AND RAN AND RAN AND RAN AND RAN AND RAN

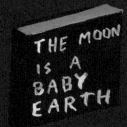

THE MOON IS A BABY EARTH

EXPLOSIONS REPLACED SUBTLETY

YOU GLOOM AND
DOOMERS MAY BE ON
TO SOMETHING

THE
GREAT

A FLY IN
OUR
MIDST

I HAVE
A
SECRET
LIFE, BUT
IT'S ALSO
BORING

HOW TO SAVE A
DROWNING SORROW

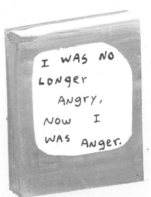

I WAS NO
LONGER
ANGRY,
NOW I
WAS ANGER.

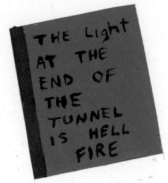

THE Light
AT THE
END OF
THE
TUNNEL
IS HELL
FIRE

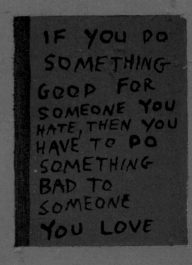

IF YOU DO
SOMETHING
GOOD FOR
SOMEONE YOU
HATE, THEN YOU
HAVE TO DO
SOMETHING
BAD TO
SOMEONE
YOU LOVE

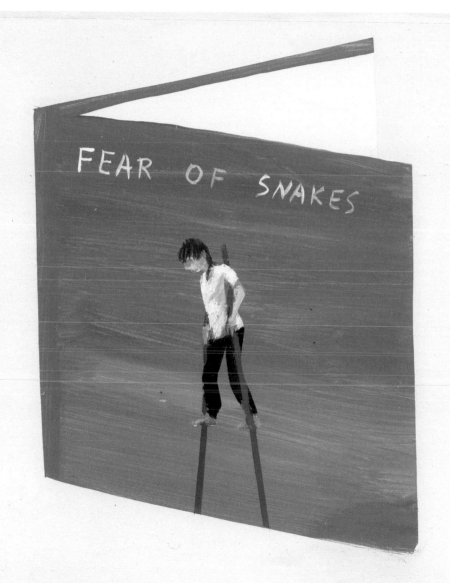

BRANCHING IN

THE OF OF OFF

THE ASHES OF OUR ENERGY

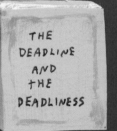

THE DEADLINE AND THE DEADLINESS

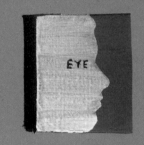

EYE

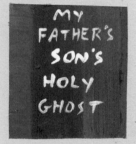

MY FATHER'S SON'S HOLY GHOST

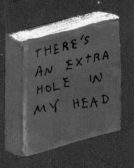

THERE'S AN EXTRA HOLE IN MY HEAD

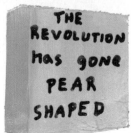

THE REVOLUTION HAS GONE PEAR SHAPED

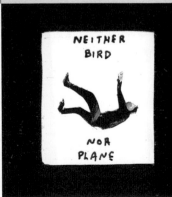

NEITHER BIRD NOR PLANE

THE
WORLD'S
GONE TO
HELL,
JUST
NOT
FOR ME

BIG NOSE
ANIMALS

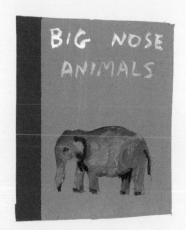

THE KIND
OF PERSON
WHO IS KIND
OF A PERSON
AND KIND
TO OTHER
PERSONS

IT'S LONELY
AT THE
TOP AND
IT'S LONELY
AT THE
BOTTOM

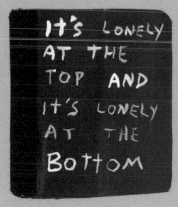

MY FRIENDS
WERE MY
FAMILY WHEN
MY FAMILY
WEREN'T
MY
FRIENDS

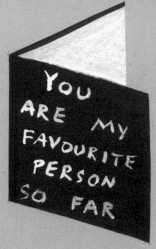

YOU
ARE MY
FAVOURITE
PERSON
SO FAR

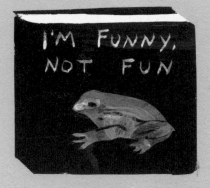

I'M FUNNY,
NOT FUN

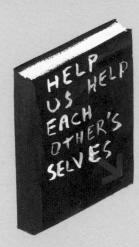

HELP
US HELP
EACH
OTHER'S
SELVES

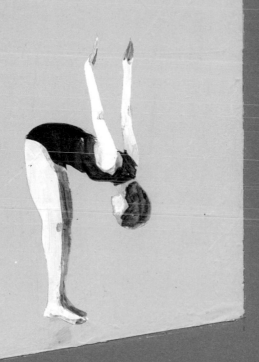

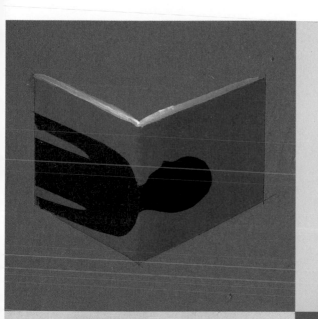

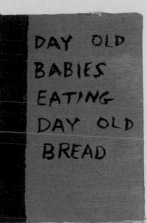

DAY OLD
BABIES
EATING
DAY OLD
BREAD

I SAID
WEIRD
STUFF
AND THEY
UNDERSTOOD
ME

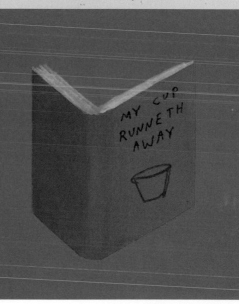

MY CUP
RUNNETH
AWAY

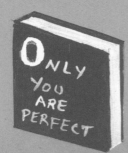

ONLY YOU ARE PERFECT

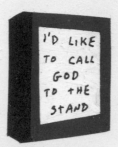

I'D LIKE TO CALL GOD TO +HE STAND

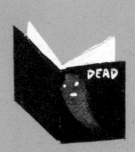

DEAD

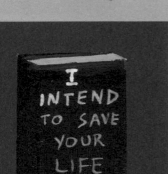

I INTEND TO SAVE YOUR LIFE

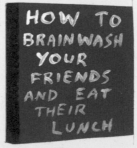

HOW TO BRAINWASH YOUR FRIENDS AND EAT THEIR LUNCH

BABY SEEDY EFFIGY

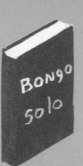

BONGO SOLO

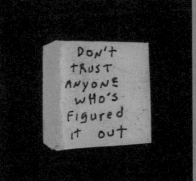

DON'T TRUST ANYONE WHO'S FIGURED IT OUT

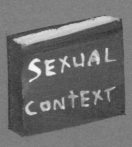

SEXUAL CONTEXT

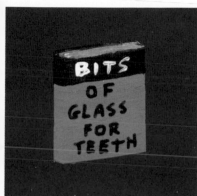
BITS OF GLASS FOR TEETH

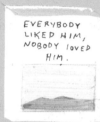
EVERYBODY LIKED HIM, NOBODY loved HIM.

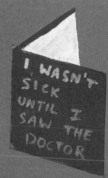
I WASN'T SICK UNTIL I SAW THE DOCTOR

I WANTED TO HOLD YOUR HAND AND NOW I'VE DONE IT

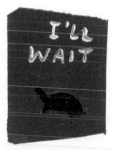
I'LL WAIT

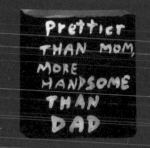
Prettier THAN MOM, MORE HANDSOME THAN DAD

YES I LOVE HIM, YES HE'S A JERK

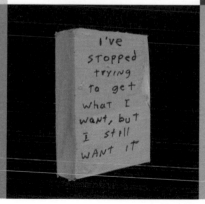
I've STOPPED trying to get what I want, but I still WANT IT

THE GOOSE LAID GOLD AND THEN Silver AND THEN bronze Eggs

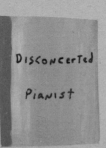

Disconcerted

Pianist

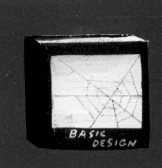

BASIC
DESIGN

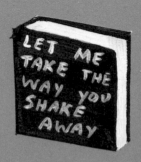

LET ME
TAKE THE
WAY YOU
SHAKE
AWAY

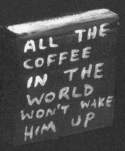

ALL THE
COFFEE
IN THE
WORLD
WON'T WAKE
HIM UP

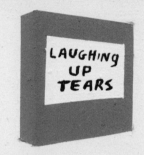

LAUGHING
UP
TEARS

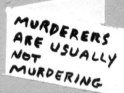

MURDERERS
ARE USUALLY
NOT
MURDERING

DON'T MIND
IF I DO OR
DON'T.

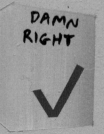

DAMN
RIGHT

✓

SHE
STOLE YOUR
HEART, I
STOLE YOUR
LUNGS

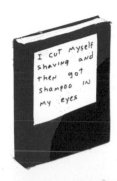

I CUT myself shaving and then got shampoo IN my eyes

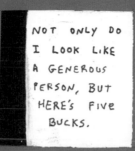

NOT ONLY DO I LOOK LIKE A GENEROUS PERSON, BUT HERE'S FIVE BUCKS.

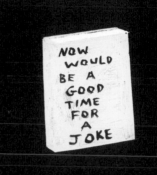

NOW WOULD BE A GOOD TIME FOR A JOKE

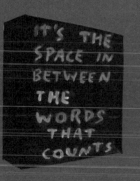

IT'S THE SPACE IN BETWEEN THE WORDS THAT COUNTS

A SKELETON ISN'T A PERSON

NO MORE ADDICTIONS STARTING TODAY

FLOWERS BEFORE THE PLOW

DIZZINESS ABOUNDS

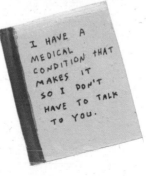

I HAVE A MEDICAL CONDITION THAT MAKES IT SO I DON'T HAVE TO TALK TO YOU.

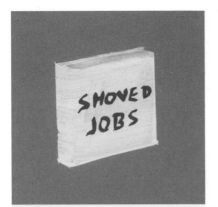

SHOVED JOBS

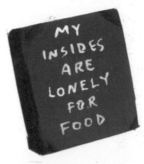

MY INSIDES ARE LONELY FOR FOOD

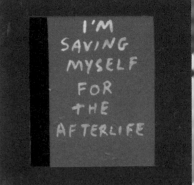

I'M SAVING MYSELF FOR THE AFTERLIFE

RUE AND BLED

EVERY DAY IS A DAY WITHOUT TELEPORTATION

THE DOOR IS CLOTHED

ALL IS LOST AND FOUND

HOW DARE YOU NOT

YOU KILLED HIM. YOU BRING HIM BACK TO LIFE.

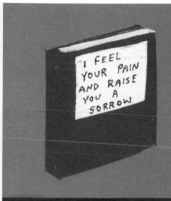

"I FEEL YOUR PAIN AND RAISE YOU A SORROW

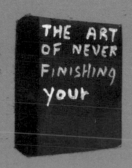

THE ART OF NEVER FINISHING YOUR

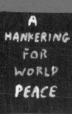

A HANKERING FOR WORLD PEACE

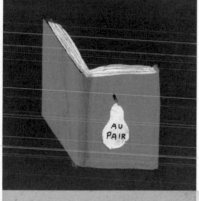

AU PAIR

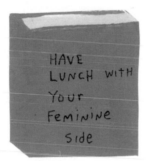

HAVE LUNCH WITH YOUR FEMININE SIDE

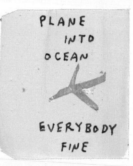

PLANE INTO OCEAN

EVERYBODY FINE

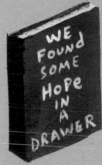

WE FOUND SOME HOPE IN A DRAWER

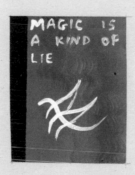

MAGIC IS A KIND OF LIE

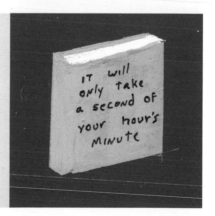

IT WILL ONLY TAKE a SECOND OF YOUR HOUR'S MINUTE

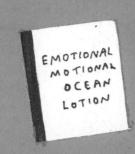

EMOTIONAL
MOTIONAL
OCEAN
LOTION

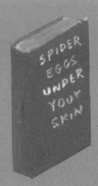

SPIDER
EGGS
UNDER
YOUR
SKIN

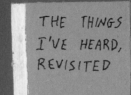

THE THINGS
I'VE HEARD,
REVISITED

ELLA

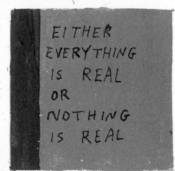

EITHER
EVERYTHING
IS REAL
OR
NOTHING
IS REAL

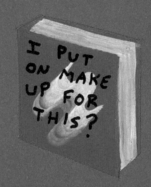

I PUT
ON MAKE
UP FOR
THIS?

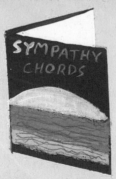

SYMPATHY
CHORDS

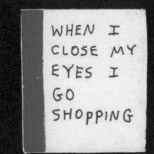

WHEN I
CLOSE MY
EYES I
GO
SHOPPING

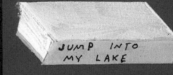

JUMP INTO
MY LAKE

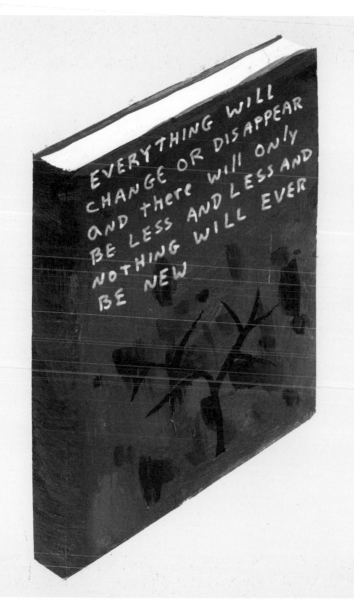

NOBODY LOVES
YOU, BUT WHO
CARES, THEY'RE
NOBODY.

From The
SECOND he
WAS Born UNTiL
the SECOND
He died he Was
NOTHing but
trouble

ALL
THINGS
TO
ALL
PEOPLE,
AND
MORE

CORRECTIONS

AMORAL
BUT
ARTISTIC
PHOTOGRAPHS

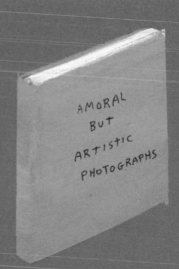

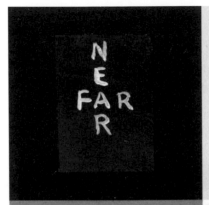

NE
FAR

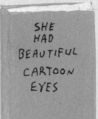

SHE
HAD
BEAUTIFUL
CARTOON
EYES

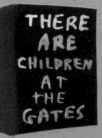

THERE
ARE
CHILDREN
AT
THE
GATES

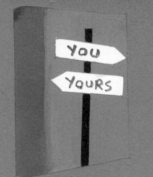

YOU

YOURS

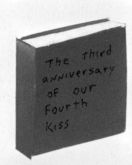

The third
anniversary
of our
Fourth
Kiss

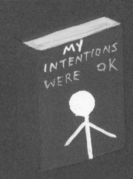

MY
INTENTIONS
WERE OK

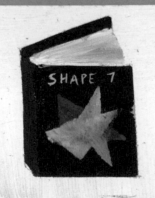

SHAPE 7

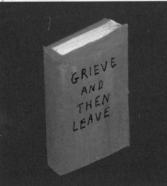

GRIEVE
AND
THEN
LEAVE

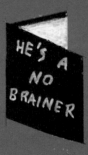

HE'S A
NO
BRAINER

I HUNTED YOU AND
THEN YOU HAUNTED ME

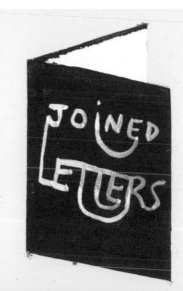

JOINED LETTERS

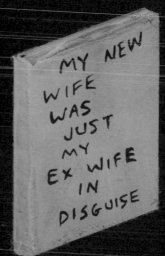

Why not make a cigarette that cures cancer INSTEAD?

MY NEW WIFE WAS JUST MY EX WIFE IN DISGUISE

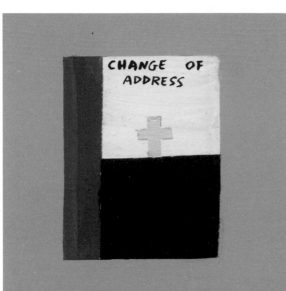

CHANGE OF ADDRESS

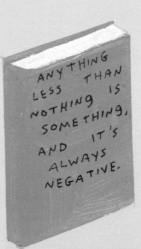

ANYTHING LESS THAN NOTHING IS SOMETHING, AND IT'S ALWAYS NEGATIVE.

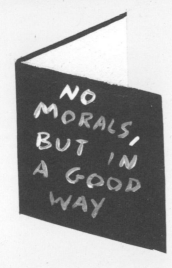

NO MORALS, BUT IN A GOOD WAY

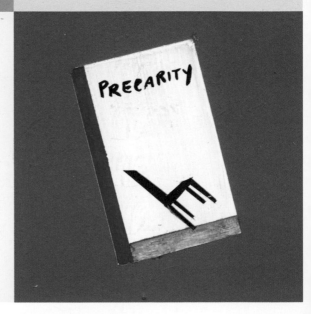

PRECARITY

THERE WAS A NEW EMOTION, AND I WAS THE FIRST PERSON TO FEEL IT, AND THEY NAMED IT AFTER ME.

Just looking for some
dust to sweep

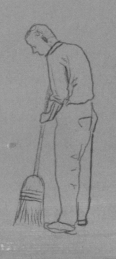

Thank you to

Everyone at Drawn & Quarterly

Galerie Blouin Division
Patel Brown Gallery
Richard Heller Gallery

Connie, Enn, Fay
Krista
Jon Klassen

Very special thanks to Jen
and Ed Kernaghan

All paintings 2013-2021, 1:1 scale

Michael Dumontier and Neil
Farber are founding members
of the Royal Art Lodge. Since
the dissolution of the influential
Winnipeg art collective, Dumontier
and Farber continue to work and
create art together. They both
reside in Winnipeg, Canada.